post-digital PAINTING

CRANBROOK ART MUSEUM

Post-Digital Painting

Cranbrook Art Museum
Bloomfield Hills, Michigan
December 14, 2002 – March 23, 2003

This catalogue was published in conjunction with an exhibition
organized by Cranbrook Art Museum and curated by Joe Houston.

Editor: Dora Apel
Design: Christian Unverzagt with Craig Somers, M1, Detroit, Michigan
Typeset in Monotype Grotesque, OCR-K, Scala and Scala Sans
Printed in Germany by Cantz

Cover image: Peter Zimmermann, *Strip B*, 2002
(detail) epoxy on canvas, 49-1/4 x 98-1/2 in.

ISBN 0-9668577-4-7

CONTENTS

FOREWORD and ACKNOWLEDGMENTS

As information and communication become more multidimensional in the digital age, so too does the nature of art become more hybrid, and the traditional borders between media less clear. Despite sophisticated multimedia techniques available today, especially those enabled by computer technology, the handcrafted medium of painting ironically has lost none of its urgency and appeal. In fact, painting provides individual perspectives on our encoded media age that are perhaps more evocative than any of the electronically derived images with which we have become so familiar. Painting not only has been impacted by our environment of endlessly proliferating images, but demonstrates how the nature of vision itself has changed in the 21st century. In *Post-Digital Painting*, Joe Houston has evidenced an acutely discerning curatorial vision and provides a thoughtful essay contextualizing painting within the development of visual technologies as well as insightful essays on the works themselves. He was aided by an energetic team at Cranbrook Art Museum, in particular Roberta Frey Gilboe, George Doles, Elena Ivanova, Ellen Dodington and Ryan Hobbs, as well as the catalogue's designer Christian Unverzagt, and editor Dora Apel.

Joe and I both would like to thank the following dealers in Chicago, Ferndale, London, Los Angeles, New York and Santa Monica whose generous assistance helped us to realize this project: Robert Gunderman and Randy Sommer of ACME; Sima Familant of Artemis·Greenberg Van Doren·Gallery; Derek Eller of Derek Eller Gallery; Elizabeth Dee of Elizabeth Dee Gallery; Lora Rempel of Entwistle; Hudson of Feature, Inc.; Klemens Gasser, Tanja Grunert and Ashley Ludwig with Benjamin Cottam and Kajsa Sexton of Klemens Gasser & Tanja Grunert, Inc.; Corrine Lemberg and Darlene Carroll of Lemberg Gallery; Natalie R. Domchenko of Peter Miller Gallery; Roger

2

Ramsay of Roger Ramsay Gallery; Ronald Feldman and Marc Nochella of Ronald Feldman Fine Arts; Shoshana Blank and Corrina H. Wright of Shoshana Wayne Gallery; Michael Solway and Angela Jones of Solway Jones Gallery; and Stefan Stux and Michael Weiss of Stefan Stux Gallery. Along with these dealers, we also are extremely grateful to the collectors, including Burt Aaron, Baker Bloodworth, Susan and Michael Hort, Kimberly Light, Ninah and Michael Lynne, Peter Remes, Barry Sloane, Michael Stewart, and several others who wish to remain anonymous, who generously loaned works in their collections for the exhibition.

Post-Digital Painting would not have been possible without the guidance of the Museum Committee of Cranbrook Art Museum. Under the leadership of David Klein and Maxine Frankel, and with the full support of our Board of Governors and Cranbrook President Rick Nahm and Academy of Art Director Gerhardt Knodel, the committee has championed our role as a leading forum for contemporary art, architecture and design. I also thank Burt Aaron, the Maxine and Stuart Frankel Foundation, David Klein and Kate Ostrove, and Mr. and Mrs. Joseph A. Nathan for their generous sponsorship of this exhibition and catalogue.

Finally, Joe and I offer our heartfelt appreciation to the twelve artists included in this exhibition for providing signposts into this post-digital era. We are delighted to be able to share their work with the many audiences of Cranbrook Art Museum.

Gregory Wittkopp
Director, Cranbrook Art Museum

3

RECOMBINANT VISION

ALEX BROWN
TNC, 2001
(detail) oil on canvas, 67 x 73 in.

The world is undergoing a seismic technological transformation that is radically altering our perception. The decoding of the human genome is just one index of the fundamental paradigm shift in our 21st-century worldview. As a result of the computer, all objects of study, biological and otherwise, are now subject to numerical abstraction, the binary language of 0s and 1s that translates all knowledge into discrete and reconfigurable bits of information. We literally *see* differently in this post-digital environment, vision itself becoming a much more interactive process in a codified, electronically connected, hypermediated world.

 The low-tech medium of painting has had to retool itself to keep pace with this evolving condition. It was not long ago that painting was mired in the discourse of its own nostalgia, and diverse modes of simulation, self-critique and neo-romanticism were systematically deployed by artists in an effort to memorialize the medium in postmodern polemics. In the past few years, however, painting again has been rehabilitated to engage the new perceptual paradigm of the digital, which must be graphically represented in order to be comprehended. The methodologies of inscribing the digital perspective onto the painted surface reflect the multivalent and fluctuating nature of information space and our social interaction on its virtual terrain. Scanning, deconstruction, montage, mutation, hybridization, synchronicity, and temporal anomaly are all made visible.

It is ironic that the traditional craft of painting is providing perhaps one of the clearest reflections of the perceptual changes in our midst. Precisely because it can delineate individual viewpoint, painting can tell us more about the effects of our digitized, media-saturated world than can any mechanical representation. Biased by the human hand, it provides a revealing record of visuality, the view of the world that is culturally contingent, shaped by the philosophical and techno-logical conditions of the day. Of all the elements that comprise the painted image, the feature that most defines the historical point of view is *perspective*, the spatial discourse embedded within its surfaces.

The ideological implications of perspective are epitomized by the Renaissance technique of linear perspective which prescribed the geometric rendering of 3-dimensional space into grid form. This system, which is often characterized by a single vanishing point, did not mirror retinal experience but depicted an abstracted version of it as interpreted by intellect. By defining the world so logically and con-sistently in fixed coordinates, Quattrocentro painters propagated a centralized view of the world as jointly ordered by mathematics and divinity. This image of geometric stability was, in turn, concretized in the urban architecture of the period, its churches and piazzas pattern-ing for pedestrians a truly kinesthetic experience of symmetry and proportion that reinforced a divine harmony. This rationale contrasts distinctly with Chinese painting of the 15th century which represents a pictorial space that is typically decentered, unhierarchical and without a definable vanishing point, a perspective that embodied the Taoist belief of the Ming Dynasty that all material nature is a locus of energy. This simple contrast of dominant Eastern and Western aesthetic philosophies offers compelling proof of the programmatic and changing nature of perspectival systems.

In the modern era, science and technology largely displaced spirituality in shaping both culture and aesthetics. Photography, in particular, had a profound effect on visual perspective, modeling a monocular, mechanical view of the world embalmed in a chemical stasis. The new medium impacted painting in diverse ways: by freeing it from mimesis, inspiring unconventional compositional strategies, and imbuing the painted image itself with an aura of authenticity amidst the widespread commercial reproduction of images. The camera, which promised a scientifically dispassionate record of nature, in time forced a renegotiation of the assumed veracity of vision. It was not long after the popularization of the medium, for instance, that techniques of montage and other darkroom chicanery could forge unnatural juxtapositions and apparitions. We now understand that even the most innocuous of snapshots establishes a biased viewpoint, implying the physical and psychological relation between the spectator and the observed. As advertising most boldly illustrates, photographs, like all forms of representation, can covertly inscribe social relations,

define sexual hierarchies and stimulate desire. Even the most benign images can harbor agendas.

Called into question by scientific innovations, the pre-modern notion of the world as a constant, immutable fact succumbed to a view of the world as a philosophical construct, a condition that informs all 20th-century manifestations of the visual. Cubist collage and Surrealist paradox provided two early strategies of critiquing conventional forms of representation, one by interrogating volumetric structure derived from linear perspective, the other by terrorizing spatial and temporal logic. Together they signaled the deconstruction and reconfiguration of nature that attended evolving metaphysical precepts. Space and time were conjoined in Einstein's theory of relativity, wherein matter itself became a responsive and dynamic entity.

Once physical nature could be viewed in such a revolutionary light, painters unleashed an avant-garde progression of pictorial strategies, each one subverting further the empirical view of nature. Renaissance perspective and other historical models were no longer suitable techniques for interpreting or imagining a world where atomic fusion and black holes were possible. The emergence of video and other electronic media added new ways of recording and broadcasting the visual field from innumerable vantage points. Video now saturates the environment with a continual flow of images that mediate our experience and monitor our every action. It has insinuated the perspective of the jump cut, the split screen, and picture-in-picture into our vision. By the century's close, science and industry had manufactured an insecure world of postmodern variability. The fixed gaze of the Renaissance was now wholly supplanted by an ever shifting viewpoint of unfolding contingencies, the heterogeneous perspective of an emerging computational cosmology.

All technologies, no matter how modest they may at first appear, have the power to effect radical intellectual, ideological and social change. In his influential essays on media, Marshall McLuhan poignantly conveys the impact that the humble light bulb had on civilization by freeing people from the "tyranny" of night and day, increasing industrial production, and forever transforming human relations. By comparison, we can only imagine how profound the consequences a tool as multifunctional and pervasive as the computer will ultimately have on our lives. The conversion of analog reality illuminated by Edison's burning filament into the digital virtuality afforded by the microprocessing chip is unparalleled. By allowing us to reshape our material nature, which is the ultimate goal of the Human Genome Project, this technology is already transforming our fundamental perception of the world. Now central to our lives in so many ways, the computer assures our continuing digital evolution wherein the laws of nature are supplanted by the logic of code.

The computer has provided us with a new means of re-envisioning the material world in infinite ways. Its algorithms can propose a myriad of new objects, spaces and events. With it we can safely scan and examine strata of living tissue, engineer dynamic architectural structures in simulated environments, or model and predict ecological change. Information of all kinds is graphically displayed on our desktops, rendering all knowledge visual. The sheer volume and velocity of visual data in our media-connected society requires that we more and more become actively engaged in interpreting images. The visual field is now a discontinuous realm of data like any other. The corporeal and the digital are beginning to collapse in our increasing technological immersion.

Cybernetic theory prefigured this integration of the visceral and the virtual more than a half century ago. Norbert Weiner, the father of cybernetics, even postulated that because material form was the result of the organization of information, it would be possible to "telegraph" living organisms once our genetic messages could be decoded into so many dots and dashes. While beaming a human being from one location to another remains science fiction, in some ways Weiner's prophecy has come true. Warfare employs bilocation techniques derived from the video arcade to remotely engage targets through the electronic eye of the satellite surveillance camera. In another realm, nanotechnologists are refining processes of true molecular alchemy with the development of nanobots that can reassemble atoms into any desired pattern. And bioengineering has realized the generation of human tissue from encoded cellular material, allowing us to essentially rewrite our own biological messages.

In the post-Genome world it may only be a matter of time before our visceral bodies can fully enter into the rapture of the code. The theoretical possibility of this has already altered our notions of solidity and permanence, interiority and exteriority, as reflected by our buildings, our ideas of community, our stories and our images. The emerging generation of artists, like all other users in this interactive environment, travel comfortably within this domain of syntactical uncertainty. Their perceptive images circumscribe the dialectic between visuality and materiality, simultaneously mirroring and reconstructing our world.

Joe Houston
Curator of Exhibitions, Cranbrook Art Museum

THE ARTISTS

Scott Anderson
Philip Argent
Alex Brown
Benjamin Edwards
Chris Finley
Beverly Fishman
Carl Fudge
Dan Hays
Yeardley Leonard
Randy Wray
Amy Yoes
Peter Zimmermann

Essays by Joe Houston

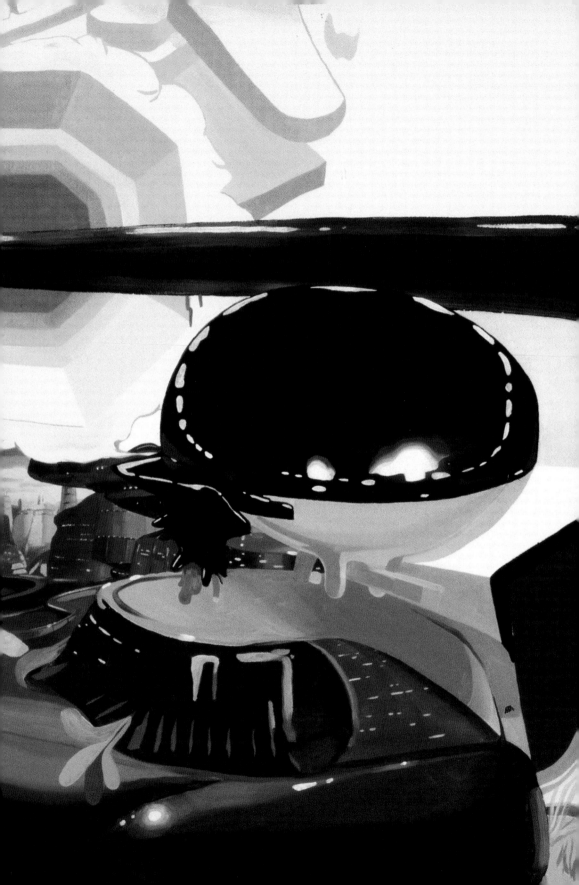

SCOTT ANDERSON

The cast-away objects of consumer culture take root in Scott Anderson's parallel universe. In the limitless dimension of his surreal canvases, buildings and manufactured goods escape the gravitational pull of suburbia and reconfigure according to their own perverse logic. In this fantasy realm, the detritus of the modern world accumulates into sprawling colonies with no fixed identity. The artist's eccentric vision of libertarian excess is echoed in his titles, which are written in Esperanto, the artificial, parallel language that once promised to unite diverse populations in a multicultural utopia that has proven all too elusive.

Razeno Knabo, translated to "Lawn Boy" in English, features a dizzying conglomeration of melding objects and spatial contortions. Materiality is fluid and dynamic in Anderson's convulsing composition of unctuous, polymorphic forms. The title is one of the few clues we have to identify the central green and black shape, which looms large over the Chicago skyline, as derived from a lawnmower. A commonplace tool used to reshape nature to our own designs, the lawnmower becomes a volatile cosmic force in *Razeno Knabo*, which connotes the insidiousness of urban planning.

Anderson's multivalent approach to painting has its precedents in the subconscious landscapes of Salvador Dali and the psychedelic funk of Peter Saul. But Anderson diverges from them in his transgression of a cohesive pictorial space. Thwarting narrative and pictorial structure, the logic of perspective is everywhere subverted by competing stylistic modes, including trompe l'oeil illusion, sci-fi illustration, gestural abstraction, and the banded gradients of the computer screen. His perspective finds its closest model in the virtual codespace of the video game where disjuncture, simultaneity, and paradox are the rule. Like the romance of Esperanto a century ago, cyberspace holds for our era a promise of global heterogeneity, but one which is always in peril of spiraling into a communal dystopia.

SCOTT ANDERSON
Suna Flagari, 2000
oil and enamel on canvas, 35 x 44 in.

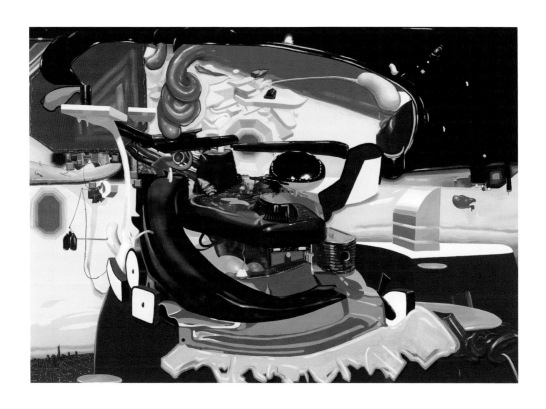

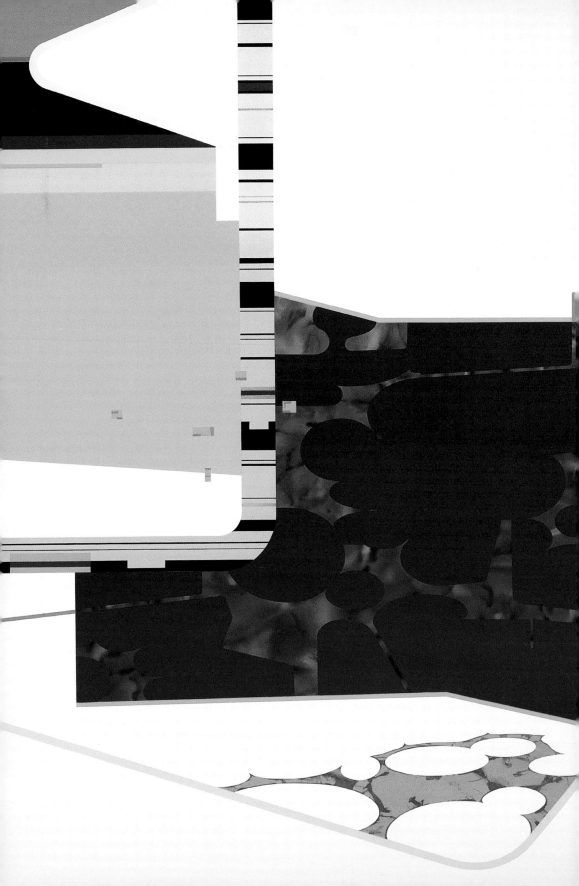

PHILIP ARGENT

The internet has altered the flow of information in our electronically connected culture. Ideas stream more discursively now as concepts easily can be linked from disparate sources into reconfigurable chains of meaning. Our thought processes are made more flexible by the new epistemological model of hypertext, the nonhierarchical interconnection of data which structures knowledge in cyberspace. This new language-of-links finds its pictorial expression in the disjunctive paintings of Philip Argent who envisions the picture plane as a void into which imagery randomly downloads. With cascading windows of texture and pattern the artist recasts the modernist aesthetic of "painterly incident" in the technological terms of the World Wide Web.

Argent's synthetic abstractions sample an assortment of formal motifs. The elegant *Untitled (Incline)* is populated by overlapping windows of geometric pattern and horizontal bands of pure color. Within its pristine acrylic surface, the saturated hues, even contours and smooth gradients echo the automated effects of graphic design and computer animation. Even where texture is implied by irregular brushwork, as behind the cartoonish cloud-like formations, it has little expressive value, looking much like textures mapped by software. Although Argent's paintings make shorthand references to landscape, the interference of disconnected linear fragments, resembling artifacts of undecrypted code, interrupt any cohesive reading of his imagery. Like the rambling experience of surfing the web, *Untitled (Incline)* beguiles, yet remains open-ended.

We have become accustomed to Argent's parenthetical, picture-in-picture view of the world. Times Square, CNN and Microsoft Windows have helped to pattern an environment of superimposition for the multitasking populace of the 21st century. The split-screens and pop-up windows that now adorn our televisions, computer monitors, and plazas have transformed our status from that of spectators to users. Accumulated from vacant fragments of visual data, Argent's paintings remind us that vision in the digital age is an interactive process with meaning contingent on whatever connections we can enforce.

PHILIP ARGENT
Triple Tab #4, 2002
acrylic on canvas, 50 x 70 in.

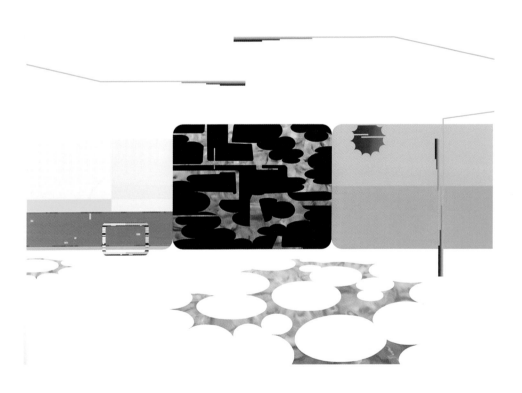

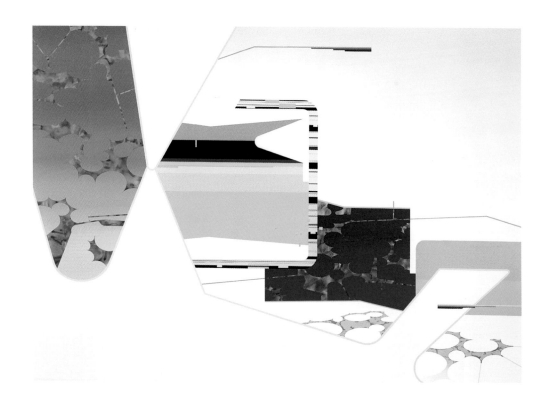

PHILIP ARGENT
Untitled (Incline), 2002
acrylic on canvas, 60 x 84 in.

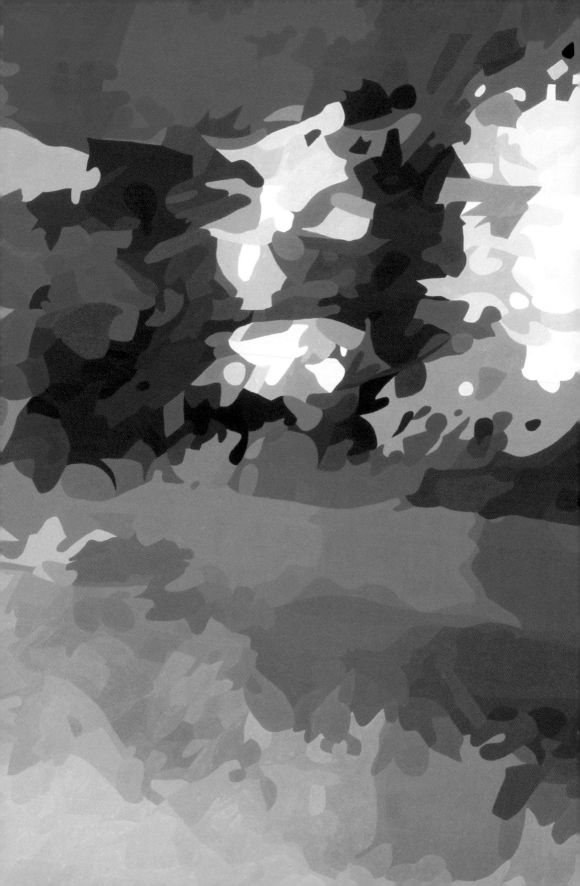

ALEX BROWN

With systematic rigor, Alex Brown reconstitutes images through an abstracting procedure of modulation. Using banal photographs culled from disparate sources such as brochures, magazines and websites, Brown sublimates the image into a standard schematic structure. Interested primarily in the formal semantics that result from the evolution of visual data, he chooses an image not for its content but for its useful formal qualities. While this procedure superficially mirrors the methods of bitmapping and filtration made possible by photo-editing programs, Brown, in fact, produces these transformations without the aid of the computer. His keen sensibility is informed nevertheless by the technologies that have impacted the contemporary viewpoint.

In the eccentric painting *Hall*, Brown has transformed a nondescript image of a hotel or office lobby into a mosaic explosion of irregular forms. With objects generalized into their nearest equivalent shapes, the resulting painting reads as both photograph and pure abstraction, invoking a marked hallucinatory effect. *TNC*, painted that same year, filters a photograph through a secondary image, essentially splicing together two disparate pictorial entities. As we stare into the lushly colored orthogonal forms that emerge throughout Brown's interpolation, our sight slips randomly between an image of an industrial park and an aerial view of a rustic landscape. Buildings take on the appearance of an ultramarine river and trees become transposed onto architectural facades. Viewing *TNC*, we see a hybridized environment as an active alchemical process.

The disjunctive visual experience that Brown so painstakingly limns for us in *TNC* is perhaps a perspective more consonant with our true experience of the world than the photographic sources he cites. He invites us to look closely at the pristine surfaces of his encrypted images, and to find satisfaction in both the excavation of familiar contours and the possible discovery of unfamiliar patterns.

ALEX BROWN
TNC, 2001
oil on canvas, 67 x 73 in.

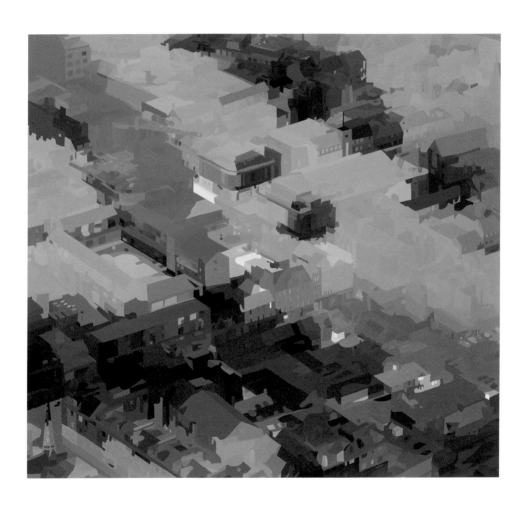

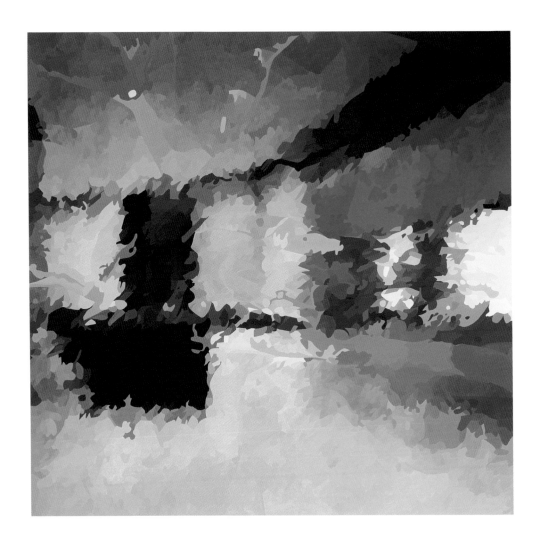

ALEX BROWN
Hall, 2001
oil on canvas, 69 x 71 in.

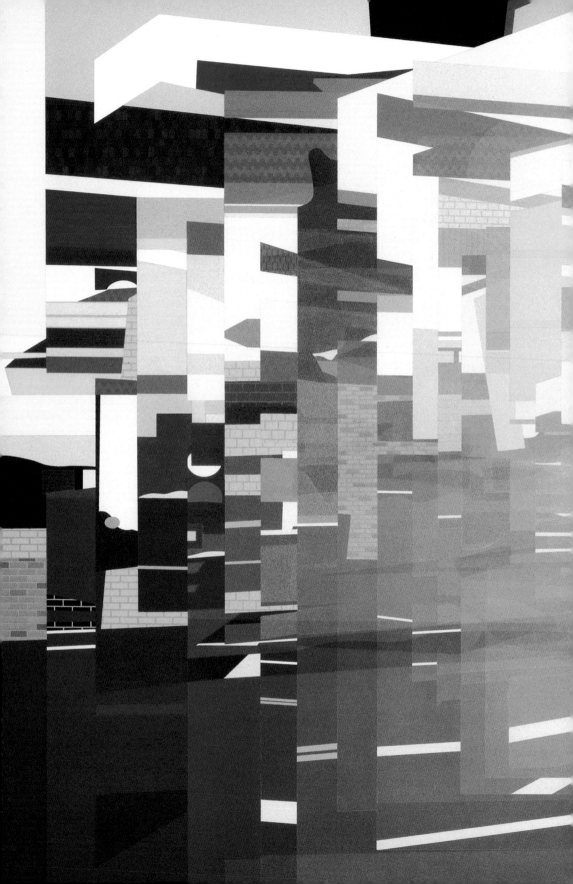

BENJAMIN EDWARDS

In densely layered paintings of prefabricated architecture, Benjamin Edwards maps the sprawling topography of American consumerism. His conglomerations convey a quintessential suburban experience processed from countless digital snapshots of fast food chains, strip malls, gas stations and office parks. Reconstituted on the computer into a single congested image, these disparate elements form an archetypal view of suburban planning, one that is at once disorienting and strangely familiar. The frenetic collision of architectural forms mirrors the aggregate landscape of our daily routine of parking and shopping, driving and parking.

Edwards' panoramic painting *Edge* resulted from a road trip taken by the artist around the perimeter of Los Angeles in 2000. With ethnographic rigor, the artist photographed over 600 industrial and commercial sites from the banal perspective of the parking lot as he circumnavigated the city. These images were then compiled and interwoven on the computer into a digital sketch that outlined a complex linear matrix for the final composition. Working from the center of his canvas towards its outside edge, he layered these structures one by one in paint, obscuring the overlapping details at the center of the composition with the addition of each successive image, the elided sections to be recycled in a companion work titled *Dump (Edge Refuse)*. The resulting superstructure evaporates into a telescoping space, maintaining solidity only at the periphery of our view. The utopian megaplex dissolves into a tantalizing mirage.

Captured frame by frame from the physical world, Edwards' mallscapes merge brick and mortar with binary code. This convergence of the material and the virtual is emblematic of our own transfiguration into the community of cyberspace. For now, however, as Edwards so deftly illustrates, we stand at the threshhold of that bewildering point of limbo between the analog world and the digital universe, both of which promise fulfillment, both of which entreat us to buy.

BENJAMIN EDWARDS

Edge, 2001

acrylic, texture mediums, landscaping foam, spray paint on canvas, 78 x 132 in.

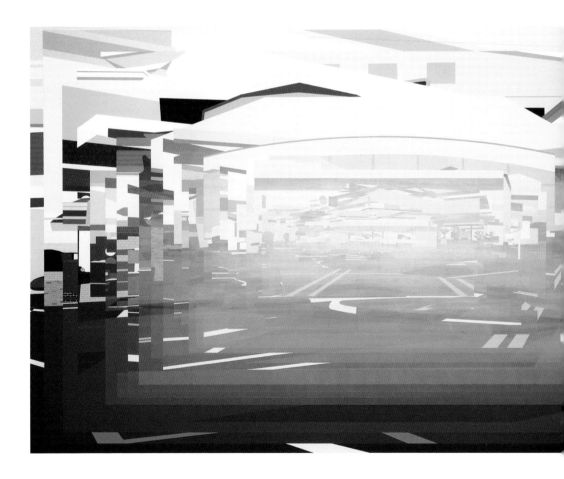

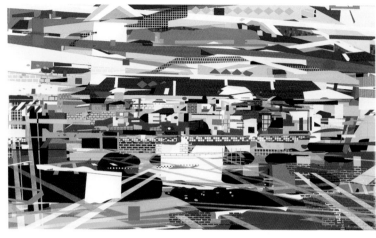

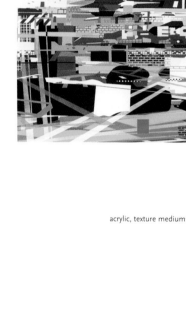

Dump (Edge Refuse), 2000–01
acrylic, texture mediums, landscaping foam, spray paint on canvas, 39 x 66 in.

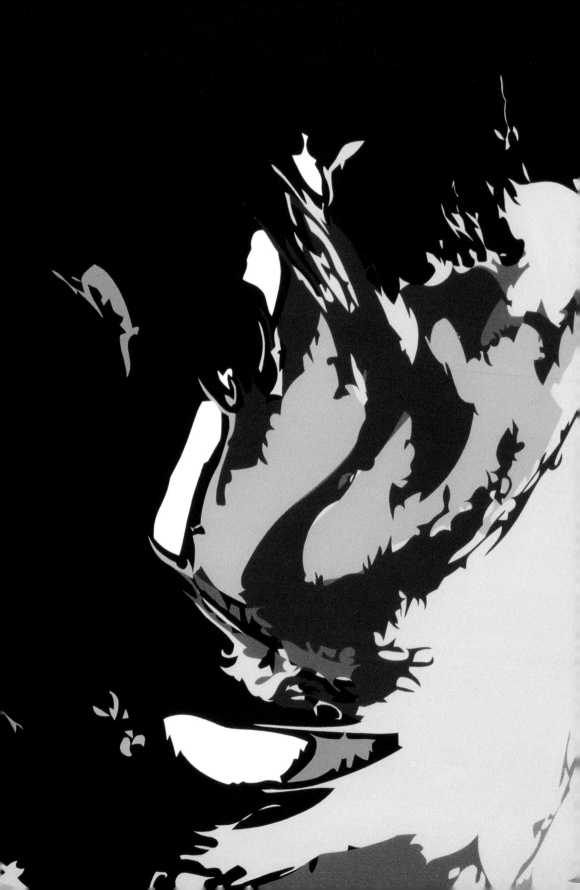

CHRIS FINLEY

Chris Finley's restless creatures navigate an environment in which space, matter and time meet in violent conflict. His paintings circumscribe the bizarre world of *gamespace*, that multi-layered, shadowless environment familiar to a generation weaned on *Space Invaders*. This virtual reality assembled from mathematical code and translated into the graphical interface of the cathode ray tube provides the futuristic landscape for the artist's cybernetic vision.

Finley's exotic concoctions are initially generated on a computer using common graphic programs such as Adobe Illustrator and Photoshop to form and morph fragments of visual data. He then painstakingly transfers the resulting digital matrix and its corresponding screen colors onto his canvas. In the process, the natural tendencies of the artist's hand are superceded by the algorithms of the computer's software, resulting in strangely mechanical contours and incongruous compositions. This creative merging between technology and craftsmanship creates an uneasy tension within the glossy enamel surfaces of Finley's paintings.

As with many of Finley's paintings, it is difficult to identify the animated subject of *Buddhacreaturetwirl*, but its multifarious origins can be inferred from its hybrid title. The alien figure contorts, disintegrates and reconfigures as if materially transformed by the sheer velocity of its own movements. Frozen in warp speed, Finley's comic chimera articulates a fantastic yet flawed universe as promised by the processor chip, one capable of extreme alchemy but in periodic need of rebooting.

Buddhacreaturetwirl, 2001

Acrylic sign enamel on canvas over wood, 48 x 54 in.

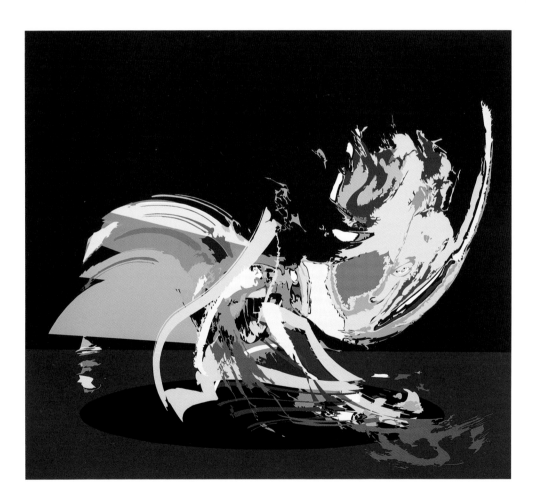

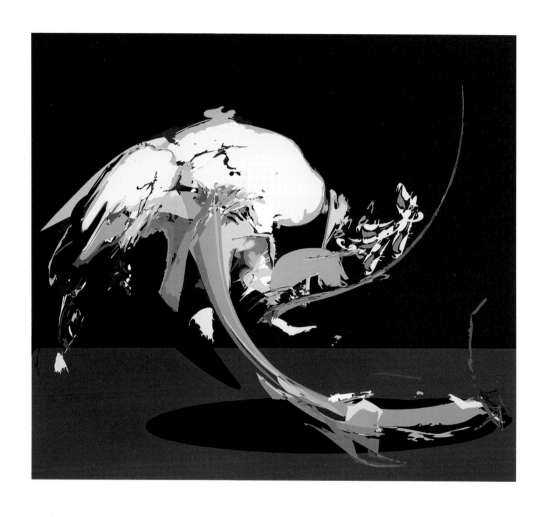

Couplinkmoundtwirl, 2001
Acrylic sign enamel on canvas over wood, 48 x 54 in.

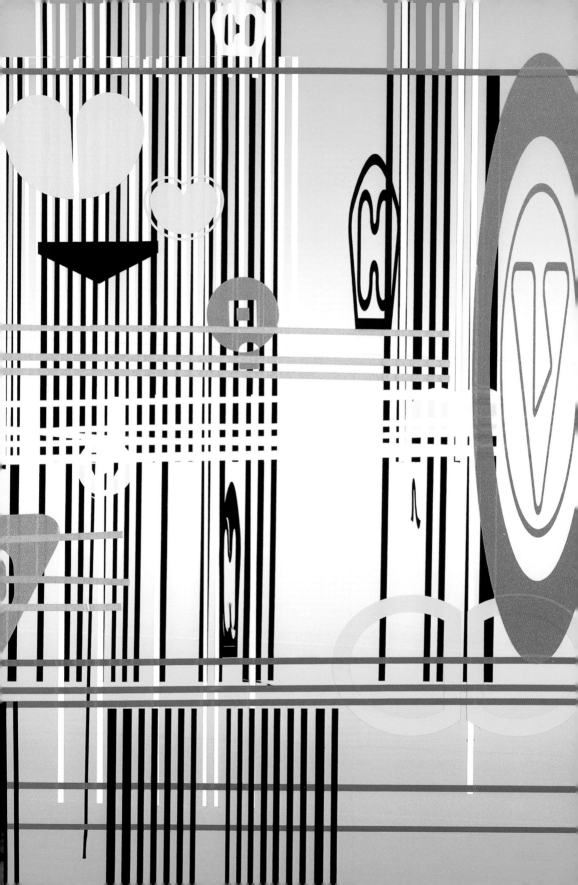

BEVERLY FISHMAN

The computer has ushered in a quantum shift in our notion of evolution. With the genomic map spelling out its essential vocabulary, the human body can now be sampled, recoded and duplicated as any message can, allowing us to essentially rewrite our own biology. As critic Donna Haraway notes in her 1985 essay, *A Cyborg Manifesto*, in the digital age, "No objects, spaces or bodies are sacred in themselves; any component can be interfaced with any other if the proper standard, the proper code, can be constructed for processing signals in common language." In her vivid paintings, Beverly Fishman gives visual form to that language, graphically rendering the communication between the digital and the biological. She delineates in abstract terms the mixed signals that now dwell within us.

Using the landscape of neurological processing as her metaphor, Fishman finds a parallel system for picturing the post-digital body. In the atmospheric *Dividose: T.V.H.*, graphic incidents unfold across a trio of horizontal panels. Stacked vertically, they make possible reference to multiple plateaux of consciousness as well as to the simultaneity that characterizes our very being in an online, hypermediated environment. Within these psychic windows linear patterns warp and weft their way across the picture plane in the process of scripting some inexplicable code. As they align and disassemble, pharmaceutical emblems intervene, gliding and submerging with abandon, attempting to reroute the transmissions. The stylish pill forms, constituting a plethora of mood-altering designer drugs, symbolize the medical and corporate recoding of the contemporary body.

The tension between biology and technology is reinforced by Fishman's painting technique, which employs computer cut vinyl adhered to powder-coated aluminum panels. Although her abstract plastic forms are mechanically generated, they are applied to the metal by hand, introducing a slight but significant human variable into the process. In seeking a means of representation appropriate to our age, Fishman reinterprets the language of painting, reinvigorating the tradition of formalist abstraction with the aesthetic urgency of advertising, design and the desktop window. Part critique, part rave, her delirious images seductively embody our increasing physical and psychological incorporation into the new ecstasy of the Code.

BEVERLY FISHMAN

Dividose: T.V.H., 2002

vinyl on powder-coated metal, 43 x 60 in. overall

BEVERLY FISHMAN
Dividose: T.B.C., 2002
vinyl on powder-coated metal, 50 x 72 in. overall

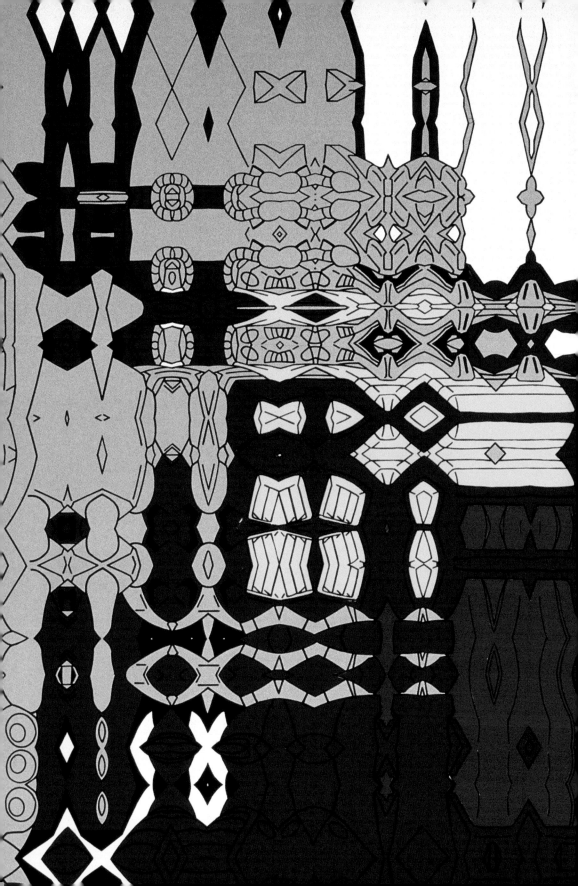

CARL FUDGE

Matter, in essence, is a modular system that theoretically can be reconfigured at will given the tools to do so. Nanotechnology promises to one day provide those tools in the form of molecular-sized machines capable of reassembling nature at the atomic level. However, as science fiction cautions, it is plausible that once created, these nanobots could become self-replicating machines, duplicating themselves until all matter was transformed in their own image. This conundrum of scientific progress forms the ironic subtext to Carl Fudge's recent paintings and prints, which harness the processes of abstraction to symbolize the virulence of uncontrollable technology.

Using as his model the plastic Japanese robots that metamorphose into a multitude of armored, weaponized figures, Fudge scans and manipulates their mechanical forms to the point of abstraction. From this matrix, he generates kaleidoscopic networks of line and color that are energized by the animated shapes of the cartoons and toys from which they are derived. The exquisite patterns and calligraphic contours that pulsate throughout his compositions meld diverse historical references, including Islamic mosaic, Beaux Arts ornament, and computer fractals, all of which share a dynamic essence with the shape-shifting figurine.

Maz Maz represents a schematized version of the toy plastic transformer squaring off at the viewer in combative stance. Linear networks screened and painted onto the canvas appear to bifurcate and reform outside the warrior's exterior as if the bot was in the continual process of mechanical gestation. In *Dirac*, the psychedelic warrior is nearly indecipherable. Flattened into a horizontal formation it transforms itself into a comic landscape of self-replicating nodes. Named after Paul Dirac, a pioneering physicist in the field of quantum mechanics, *Dirac* illustrates the energy that motivates all matter at its most elemental level, even as its superstructure disintegrates. Fudge's sci-fi hieroglyphs transcribe the aesthetic of the digital world onto the plane of formalist abstraction, crafting geometric hybrids that vacillate playfully between the fields of art and science.

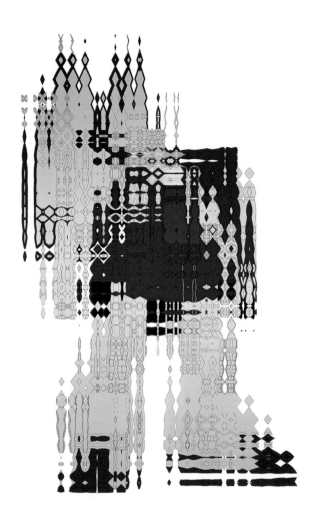

CARL FUDGE
Maz Maz, 2002
 acrylic on canvas, 86 x 57 in.

CARL FUDGE
Dirac, 2002
acrylic on canvas, 70 x 153 in.

DAN HAYS

While surfing the internet one day in 1999, Dan Hays, a London-based painter, happened upon a website maintained by Dan Hays, a Boulder-based computer executive. The site included an online gallery of webcam images of the Rocky Mountain landscape captured over a period of several years from the window of the Hays' family home. These compressed and distorted pictures caught the attention of the British artist who had long been fascinated by images filtered through print and electronic media. He received permission via email to use several of these unassuming snapshots as material for his next series of paintings.

Hays obsessively mapped these low-res mountain scenes onto canvas by carefully articulating each pixel in oil paint, ironically mimicking digital processing techniques with his brush. In its rigorous interrogation of this monolithic subject, Hays' *Colorado Impression* series owes an obvious debt to Cezanne's *Mont St. Victoire* paintings of a century ago. His pictorial digitization can indeed be viewed as a 21st-century extension of the Post-Impressionist impulse to methodically deconstruct the visual field. Viewed from a distance as panoramic vistas, the paintings become geometric patterns close up, achieving a delicate balance between the diverse traditions of romantic realism and formalist abstraction.

Painted again and again, Hays' reconstituted landscapes begin to dissolve in the process of their own engineering. Sky and tree become equally reduced to visual code. This image of the wilderness is a fleeting and fragile one that has been scanned, processed and transmitted through virtual space. Through the material act of painting, Hays finds a means by which to intricately reconstruct the technologically mediated realm of nature and download onto canvas its flickering remains, bit by bit.

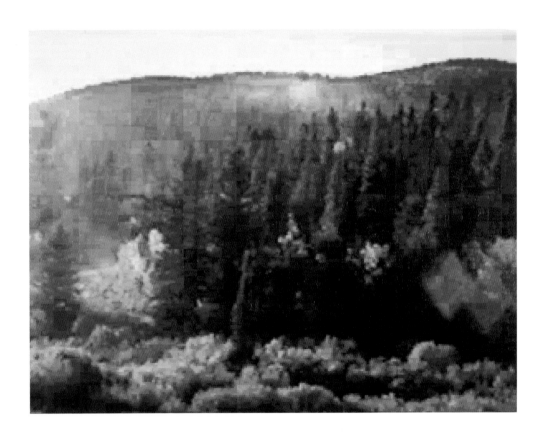

DAN HAYS
Colorado Impression X A (After Dan Hays, Colorado), 2002
oil on canvas, 59-7/8 x 78-3/4 in.

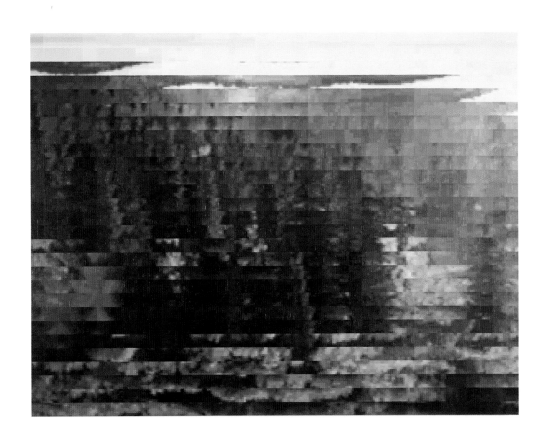

Colorado Impression X B (After Dan Hays, Colorado), 2002
oil on canvas, 59-7/8 x 78-3/4 in.

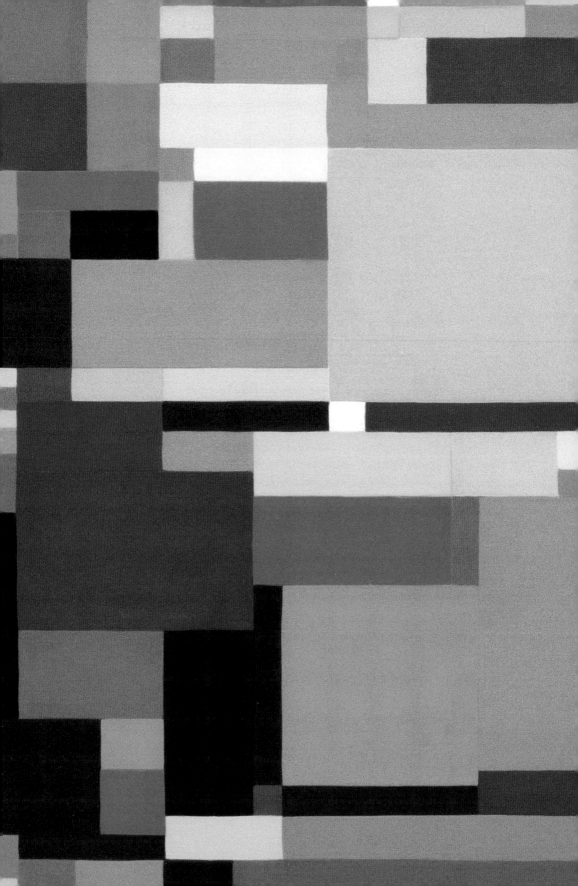

YEARDLEY LEONARD

Weaving rectilinear passages of evocative color, Yeardley Leonard creates an exquisite balance between formalist purity and anecdotal representation of the natural world. This dynamic tension between abstraction and illusion has been a fertile field of exploration for the artist throughout her career. Her early abstractions were based on a narrow vertical sampling of photographic source material. Matching hues from a limited number of reference points, she created a stratified image of the landscape as horizontal bands of color. This result is a form of minimalist stripe painting imbued with an uncanny sense of place. Historically hybrid, Leonard's stripes iterate the flatness of the picture plane while simultaneously evoking the vastness of nature.

The artist's subsequent paintings engage an even greater perceptual complexity, the picture plane proliferating into a multi-tiered field of geometric activity. While no longer direct quotations of landscape, these modernist gridworks still carry vivid allusions to nature. In works such as *Primal*, organic forms emerge faintly from the convergence of jostling rectangles, denying a purely formal reading of the painting. Though stylistically indebted to Mondrian and his de Stijl metamorphosis of nature a century ago, the small scale and subtle coloration of Leonard's contemplative works also evoke the metaphysical tradition of American Luminism.

Leonard's allusive abstractions do not reflect the world as modeled by the eye or the camera lens, but as scanned into untethered bits of information. Her shimmering compositions decode and reconfigure nature into an ethereal equivalent of itself. They suggest that technology can generate the transcendent spaces in which memory and imagination vividly coalesce.

YEARDLEY LEONARD
Primal, 2002
acrylic on canvas, 16-1/2 x 30 in.

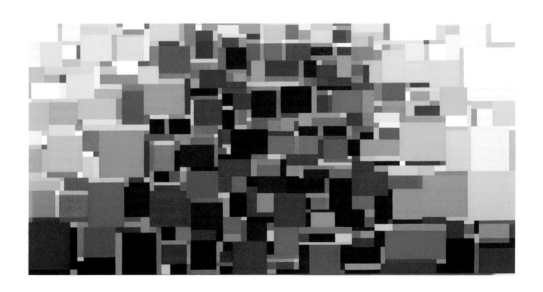

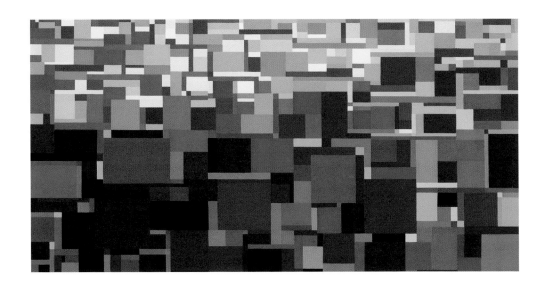

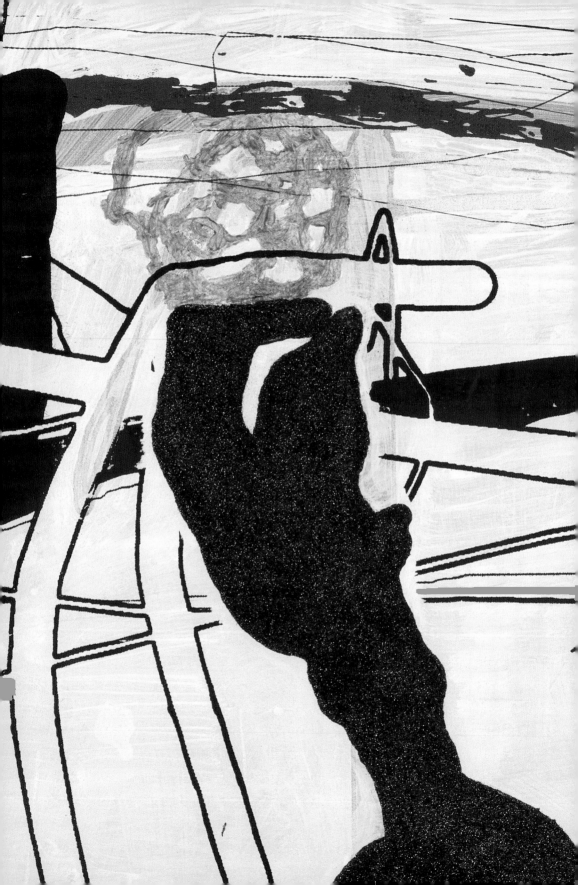

RANDY WRAY

Randy Wray's computer-assisted paintings begin with the hands-on process of sculptural assemblage. Using an array of disparate materials, including papier mâché, lobster claws, mushrooms, clay—anything that can be deployed in the creative moment—he crafts intuitive objects as a kind of psychic exercise. Encrusted and embellished, these tabletop forms take on an eccentric figural quality with physical and psychological resonance. The artist then photographs his agglomerations from numerous angles and scans them into the computer to become vectorized, rescaled, filtered and cloned for deployment in two-dimensional abstractions.

Computer-manipulated fragments form the complex web of linear activity in the mysterious painting *Episode*. Interspersed between veils of gestural brushwork, these layered elements entangle one of Wray's gnarled figures, silhouetted in relief by a crust of black grit. The abrasiveness of this cryptic image contrasts with the subtlety of the surfaces surrounding it. Images are silk-screened, washed and scumbled into a delicate membrane of painterly activity, making it difficult to ascertain Wray's materials or methods. What may at first appear to be brushed by hand sometimes reveals itself to be photographically screened into position and vice versa. The curious nature of this intricate technical process makes paintings like *Episode* both perplexing and compelling.

The computer is for Wray both a practical tool and a creative collaborator. It provides an expedient method of combining images and previewing compositions, and its algorithms can reinvent his visceral forms in even more idiosyncratic ways. This dialectic between personal intuition and technical automation coalesces to produce the artist's eccentric images. Through this creative symbiosis, Wray collapses the visceral dimension of sculpture and the virtual realm of the computer onto the ambiguous and seductive surface of painting.

Episode, 2002

acrylic, carborundum grits, micro-glitter on canvas, 30 x 24 in.

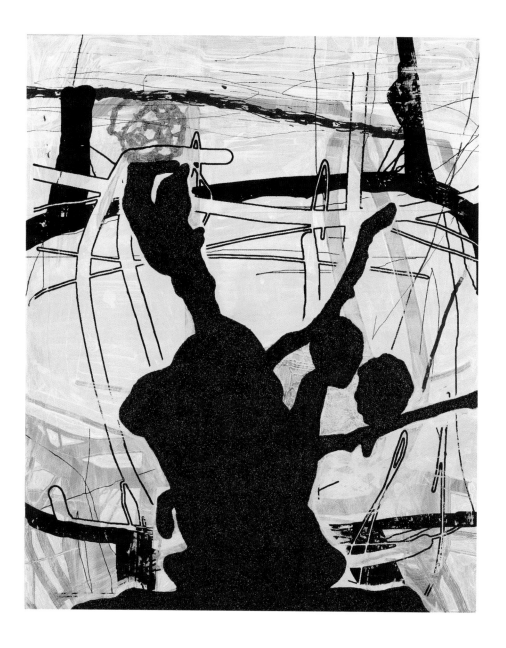

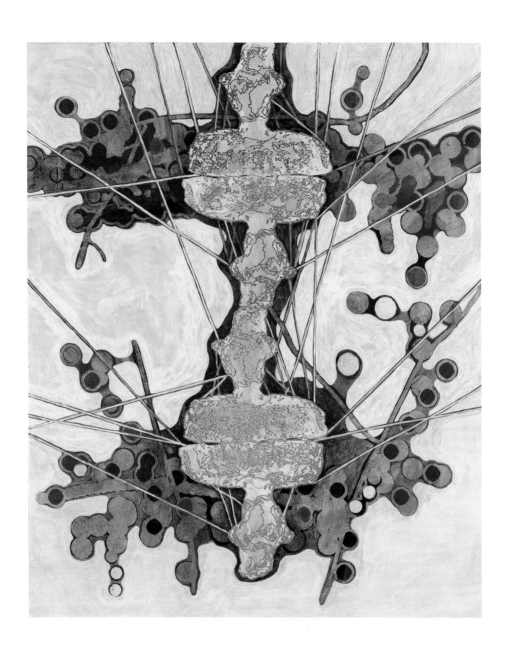

RANDY WRAY
Acrobat, 2002
acrylic, oil, glitter on canvas, 30 x 24 in.

AMY YOES

Ornamental excess approaches visual delirium in the paintings of Amy Yoes. Compiled from the innumerable embellishments that skirt the edges of architecture, furniture and paper currency, her effusive images revel in the overlooked and unappreciated details of our material world. Unhinged from their decorative moorings, these colorful ribbons, trellises, and scrollworks swarm brazenly beyond the picture plane, tantalizing and slightly terrorizing us with their unruly beauty.

In the boisterous *Dividing Thens by Nows*, Yoes positions us directly within a cultural maelstrom. Her centrifugal perspective elides all vanishing points in favor of an overall visual oscillation. Space is radically warped by the interplay of hot and cool color, contrasting patterns, and the unexpected juxtaposition of formal elements. Lime green ruffles, hot pink trims, and golden escutcheons entangle in mid-air, vying for attention. Time is made indeterminate as well by the merger of decorative motifs of diverse historical origins spanning from the Baroque to the Modern. Made plausible by image compositing software, the spatial and temporal displacement suggested in *Dividing Thens by Nows* symbolizes our unstable perspective in a world inundated and mediated by technology.

The polymorphous, conjunctive environment configured by Yoes' festive forms is one that invites abandon and celebrates the eccentric. Unhierarchical and decentered, this virtual space suggests a restructuring of the old orders of politics, economies and genders made possible by our disembodiment in the democratic realm of cyberspace. Yoes' ornamental expressionism gives this marginal reality a tactile arena in which even the slightest voice is welcome, and everything is possible, all at once.

AMY YOES
Dividing Thens by Nows, 2000
oil on canvas, 60 x 84 in.

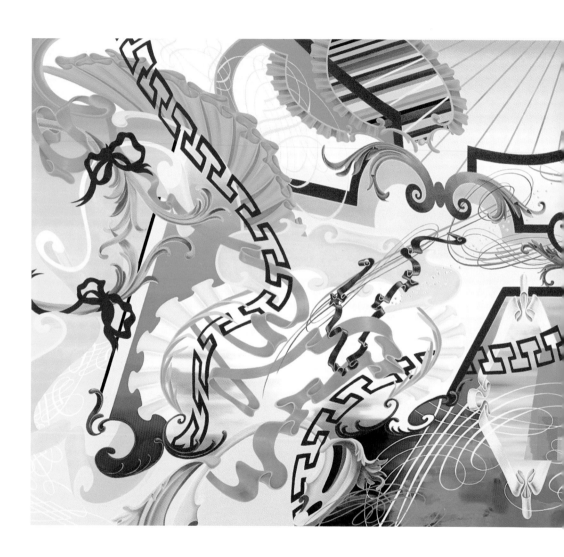

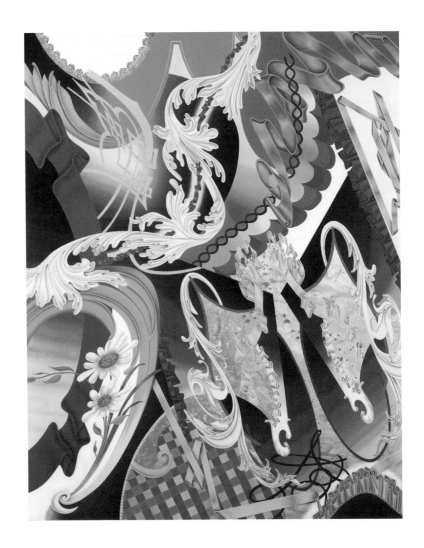

AMY YOES
Continental Murmur, 2002
oil and acrylic on linen, 60 x 48 in.

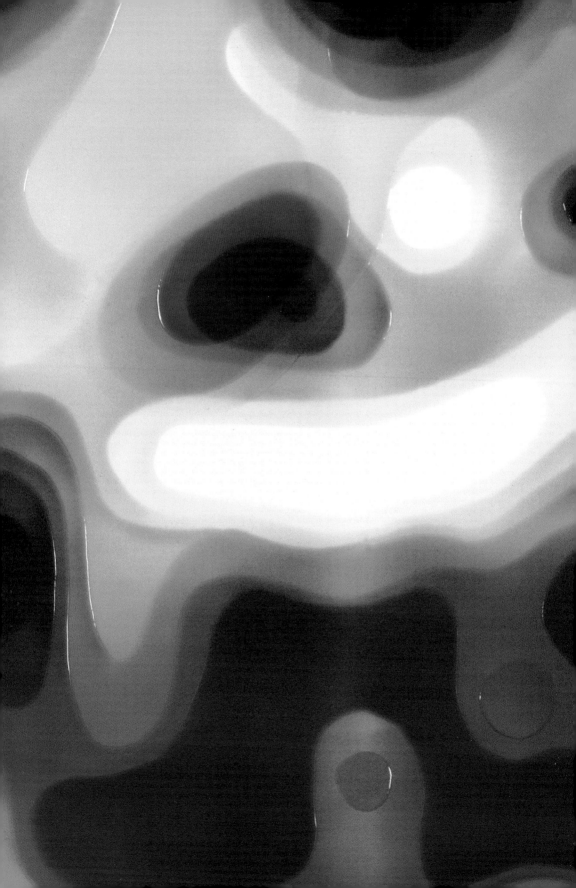

PETER ZIMMERMANN

Peter Zimmermann examines modernist painting traditions through the lens of digital technology. Using various computer filters, he deconstructs images to invoke pointillist and abstract expressionist pictorial strategies with a hint of postmodern irony. His latest paintings, created with biomorphic shapes of poured plastic resin, refer directly to the classic Color Field paintings of Morris Louis and Helen Frankenthaler, but they easily transcend that tradition to merge with a new aesthetic sensibility made possible by the computer.

Zimmermann's unique technical method utilizes digital processes to achieve sensational visual effects. To generate the colorful composition *Plastik*, Zimmermann scanned the cover image of a German art book into his computer. He then subjected this digital file to a series of common filters in Adobe Photoshop, segmenting the jacket design into a mosaic-like pattern, then blurring and mapping its contours into eccentric shapes of overlapping color. To Zimmermann the source image is usually irrelevant; he is primarily concerned with the abstraction that can result from its diverse manipulations. However, the book that generated *Plastik* still can be glimpsed remotely. Barely visible, its title refers both to the subject of art history and to the physical construction of Zimmermann's own painting.

Zimmermann projects his final digital file directly onto the canvas, then painstakingly fills in the outlines with numerous layers of pigmented and dyed acrylic resin, a technique he developed some years earlier for his large-scale replicas of glossy art book covers. Essentially a synthetic update of the old master glazing technique, his resin imparts vibrant color resulting from the refraction of light off the white canvas below the transparent plastic layers. *Plastik* literally illuminates from within. Through a combination of technical and conceptual prowess, Zimmermann relates the Medieval tradition of stained glass to the contemporary technology of the computer window. While their abstract forms are automated and processed, within their candied surfaces Zimmermann's paintings demonstrate the potential for sublime experience held by technology.

PETER ZIMMERMANN
Strip B, 2002
epoxy on canvas, 49-1/4 x 98-1/2 in.

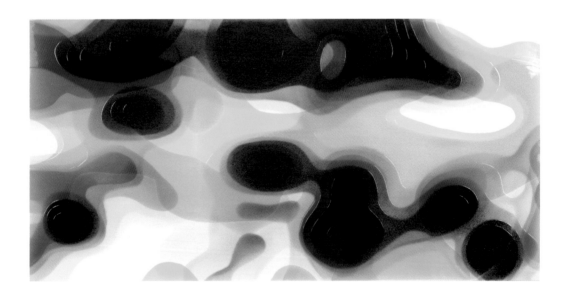

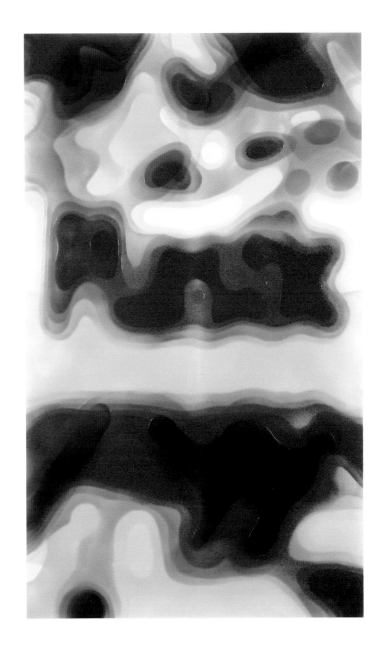

PETER ZIMMERMANN
Plastik, 2002
epoxy resin with pigments on canvas, 106-1/4 x 67 in.

SCOTT ANDERSON

Born 1973, Urbana, Illinois. Lives and works in Chicago, Illinois

EDUCATION University of Illinois at Urbana-Champaign, Illinois, MFA, 2001 · Kansas State University, Manhattan, Kansas, BFA, 1997
SELECTED SOLO EXHIBITIONS 2002 *Esperanto for Forage,* Peter Miller Gallery, Chicago, Illinois 2000 *North Prospect No. 2,* Beef and Feet Gallery, Champaign, Illinois 1996 *Epidermal,* Willard Gallery, Manhattan, Kansas
SELECTED GROUP EXHIBITIONS 2002 *Painting and Illustration,* Luckman Gallery, California State University at Los Angeles · *Social Landscape,* PPOW, New York, New York · *Nubo Wave Map (Space) Bubble,* University Galleries, Illinois State University, Normal, Illinois · *New Narratives,* Peter Miller Gallery, Chicago, Illinois 2001 *Apocalypse Next Week,* I-Space, Chicago, Illinois 2000 *Post-Americana,* 120 N. Neil, Champaign, Illinois 1999 *Dispensing with Formalities,* Temporary Services, Chicago, Illinois 1998 *New Jersey International Art Exhibition,* New Jersey Art Center, Trenton, New Jersey

12 **Suna Flagari,** 2000 oil and enamel on canvas, 35 x 44 in.
　　Courtesy of Peter Miller Gallery, Chicago, Illinois
13 **Razeno Knabo,** 2002 oil and enamel on canvas, 50 x 70 in.
　　Courtesy of Peter Miller Gallery, Chicago, Illinois

PHILIP ARGENT

Born 1957, London, England. Lives and works in Los Angeles, California

EDUCATION University of Nevada, Las Vegas, MFA, 1994 · Cheltenham School of Art, Cheltenham, England, BA, 1985
SELECTED SOLO EXHIBITIONS 2002 Shoshana Wayne Gallery, Santa Monica, California · Galerie Jette Rudolph, Berlin, Germany 2001 Shoshana Wayne Gallery, Santa Monica, California 1999 Post Gallery, Los Angeles, California · Tate, New York, New York 1996 *Hi-Fi/Sci-Fi/Lo-Fi,* Donna Beam Fine Art Gallery, University of Nevada, Las Vegas, Nevada
SELECTED GROUP EXHIBITIONS 2002 *Neo Painting,* The Young Um Museum of Contemporary Art, Seoul, Korea 2001 *The Magic Hour,* Neue Galerie am Landesmuseum Joanneum, Graz, Austria · *(LAS) VEGANS,* James Kelly Contemporary, Santa Fe, New Mexico 2000 *The Next Wave,* California Center for the Arts, Escondido, California · *Ultralounge,* Contemporary Art Museum, University of South Florida, Tampa, Florida · *Shifting Ground: Transformed Views of the American Landscape,* Henry Art Gallery, University of Washington, Seattle, Washington 1999 *Scapeland,* Henry Art Gallery, University of Washington, Seattle, Washington 1998 *Paintings from Another Planet,* Deitch Projects, New York, New York 1997 *The Vegas Show,* Rosamund Felsen Gallery, Santa Monica, California

16 **Triple Tab #4,** 2002 acrylic on canvas, 50 x 70 in.
　　Courtesy of the artist and Shoshana Wayne Gallery, Santa Monica, California
17 **Untitled (Incline),** 2002 acrylic on canvas, 60 x 84 in.
　　Courtesy of the artist and Shoshana Wayne Gallery, Santa Monica, California

ALEX BROWN

Born 1966, Des Moines, Iowa. Lives and works in Des Moines, Iowa

EDUCATION Parsons School of Design, New York, New York, BFA, 1991
SELECTED SOLO EXHIBITIONS 2003 Des Moines Art Center, Des Moines, Iowa 2002 Kevin Bruk Gallery, Miami, Florida 2001 Feature Inc., New York, New York 2000 *M du B, F, H, & g,* Montreal, Quebec, Canada · The Suburban, Oak Park, Illinois 1999 Feature Inc., New York, New York
SELECTED GROUP EXHIBITIONS 2002 *From the Observatory,* Paula Cooper Gallery, New York, New York 2001 *Not a. Lear,* Galerie S&H De Buck, Ghent, Belgium · Gracie Mansion Gallery, New York, New York · Allston Skirt Gallery, Allston, Massachusetts 2000 *Iowa Artists,* Des Moines Art Center, Des Moines, Iowa · *Glee: Painting Now,* Aldrich Museum of Contemporary Art, Ridgefield, Connecticut and Palm Beach Institute of Contemporary Art, Palm Beach, Florida · *Bit by Bit: Painting and Digital Culture,* Numark Gallery, Washington, D.C.

20 **TNC,** 2001 oil on canvas, 67 x 73 in.
　　Collection of Susan and Michael Hort, New York, New York. Courtesy of Feature, Inc., New York, New York
21 **Hall,** 2001 oil on canvas, 69 x 71 in.
　　Collection of Burt Aaron, Franklin, Michigan. Courtesy of Feature, Inc., New York, New York

BENJAMIN EDWARDS

Born 1970, Iowa City, Iowa. Lives and works in Ashton, Maryland

EDUCATION Rhode Island School of Design, Providence, Rhode Island, MFA , 1997 · Graduate Painting Program, San Francisco Art Institute, San Francisco, California, 1992 · University of California, Los Angeles (UCLA),California, BA, 1991
SELECTED SOLO EXHIBITIONS 2001 *Convergence*, Artemis·Greenberg Van Doren, New York, New York
SELECTED GROUP EXHIBITIONS 2002 *Painting As Paradox*, Artists Space, New York, New York 2002 *On Perspective*, Gallerie Faurschou, Copenhagen, Denmark 2001 *Casino 2001*, Stedelijk Museum Voor Actuele Kunst Gent (SMAK), Ghent, Belgium · *Line, Form, Color: From Hard Edge Abstraction to Architecture*, Howard House, Seattle, Washington 2000 *Greater New York*, P.S.1/ MoMA Center for Contemporary Art, Long Island City, New York · *Architecture & Memory*, Lawrence Rubin Greenberg Van Doren Fine Art, New York, New York · *Pop and After: 1965–2000*, Beth Urdang Gallery, Boston, Massachusetts 1998 *Inventory*, White Columns, New York, New York 1996 *Small Scale Landscapes*, Bernard Toale Gallery, Boston, Massachusetts

24 **Edge,** 2001 acrylic, texture mediums, landscaping foam, spray paint on canvas, 78 x 132 in.
 Collection of Peter Remes, Minneapolis, Minnesota. Courtesy of Artemis·Greenberg Van Doren·Gallery, New York, New York
25 **Dump (Edge Refuse),** 2001 acrylic, texture mediums, landscaping foam, spray paint on canvas, 39 x 66 in.
 Private Collection. Courtesy of Artemis·Greenberg Van Doren·Gallery, New York, New York

CHRIS FINLEY

Born 1971, Carmel, California. Lives and works in Rohnert Park, California

EDUCATION Art Center College of Art and Design, Pasadena, California, BFA, 1993
SELECTED SOLO EXHIBITIONS 2002 *New Work*, Tilton/Kucera Gallery, New York, New York 2000 *Warp Zone: Section 2*, Jack Tilton Gallery, New York, New York 1999 *Level Four*, Rena Bransten Gallery, San Francisco, California 1998 *Level Two*, ACME, Los Angeles, California 1997 *Level One*, ACME, Los Angeles, California
SELECTED GROUP EXHIBITIONS 2002 *2002 California Biennial*, Orange County Museum of Art, Newport Beach, California 2001 *010101: Art in Technological Times*, San Francisco Museum of Modern Art, San Francisco, California · *Game Show*, MASS MoCA, North Adams, Massachusetts · *The Sensational Line*, Museum of Contemporary Art, Denver, Colorado 2000 *Chromaform: Color in Sculpture*, Santa Barbara Contemporary Arts Forum, Santa Barbara, California · *Twisted: Urban and Visionary Landscapes in Contemporary Painting*, Van Abbe Museum, Eindhoven, The Netherlands 1999 *Attention SPAM*, Shoshana Wayne Gallery, Santa Monica, California · *Der Kleine Hans*, Christine König Galerie, Vienna, Austria 1998 *Painting from Another Planet*, Deitch Projects, New York, New York · *Juvenescence*, Chapman University, Orange, California 1997 *118W/24N L.A./USA*, Kunstverein W.A.S., Graz, Austria

28 **Buddhacreaturetwirl,** 2001 acrylic sign enamel on canvas over wood, 48 x 54 in.
 Collection of Baker Bloodworth, Los Angeles, California. Courtesy of ACME, Los Angeles, California
29 **Couplinkmoundtwirl,** 2001 acrylic sign enamel on canvas over wood, 48 x 54 in.
 Collection of Barry Sloane, Los Angeles, California. Courtesy of ACME, Los Angeles, California

BEVERLY FISHMAN

Born 1955, Philadelphia, Pennsylvania. Lives and works in Bloomfield Hills, Michigan and Los Angeles, California

EDUCATION Yale University, New Haven, Connecticut, MFA, 1980 · Philadelphia College of Art, Philadelphia, Pennsylvania, BFA, 1977
SELECTED SOLO EXHIBITIONS 2003 Solway Jones, Los Angeles, California · Lemberg Gallery, Ferndale, Michigan 2002 Boom, Oak Park, Illinois 2001 *Feel Good*, Gallery 2211, Los Angeles, California · *Pharmaco Xanadu*, White Columns, New York 2000 *Drugstore*, Post Gallery, Los Angeles, California 1998 *I.D. Series*, Susanne Hilberry Gallery, Birmingham, Michigan 1995 *Beverly Fishman: Breaking the Code*, The John J. McDonough Museum of Art, Youngstown, Ohio
SELECTED GROUP EXHIBITIONS 2002 *Bitchin Pictures*, Gallery 2211 Solway/Jones, Los Angeles, California 2001 *Made*, Post Gallery, Los Angeles, California · *Colorforms*, Detroit Artists Market, Detroit, Michigan 1999 *Light and Dark Matter*, Boulder Museum of Contemporary Art, Boulder, Colorado · *Beverly Fishman, Heather McGill, Carl Toth: Wall Magnets*, Cranbrook Art Museum, Bloomfield Hills, Michigan · *Postopia*, Craft and Folk Museum, Los Angeles, California 1998 *Prime Focus*, University Galleries, Illinois State University, Normal, Illinois · *Visualizing Digiteracy*, Memphis College of Art, Memphis, Tennessee 1997 *Flirting at a Distance: New Abstraction*, Delaware Center for Contemporary Art, Wilmington, Delaware 1996 *Technology Culture*, Erie Art Museum, Erie, Pennsylvania

32 **Dividose: T.V.H.,** 2002 vinyl on powder-coated metal, 43 x 60 in. overall
 Courtesy of Lemberg Gallery, Ferndale, Michigan and Solway/Jones, Los Angeles, California
33 **Dividose: T.B.C.,** 2002 vinyl on powder-coated metal, 50 x 72 in. overall
 Courtesy of Lemberg Gallery, Ferndale, Michigan and Solway/Jones, Los Angeles, California
 Untitled, 2002 vinyl on powder-coated metal, 18-1/2 x 12-1/2 in.
 Courtesy of Lemberg Gallery, Ferndale, Michigan and Solway/Jones, Los Angeles, California

CARL FUDGE

Born 1962, London, England. Lives and works in New York, New York

EDUCATION Brighton Polytechnic, Sussex, England, 1985–88 · Kansas City Art Institute, Kansas City, Missouri, 1987 · Tyler School of Art, Philadelphia, Pennsylvania, 1988-90
SELECTED SOLO EXHIBITIONS 2002 Ronald Feldman Fine Arts, New York, New York 2001 Bernard Toale Gallery, Boston, Massachusetts · Edward Mitterand Galerie, Geneva, Switzerland 2000 Ronald Feldman Fine Arts, New York, New York 1997 Shoshana Wayne Gallery, Santa Monica, California
SELECTED GROUP EXHIBITIONS 2002 *2002 Media Art Daejeon–New York: Special Effects,* Daejeon Municipal Museum of Art, Daejeon, Korea · *Måleri,* Galleri Charlotte Lund, Stockholm, Sweden · *New Economy Painting,* ACME, Los Angeles, California 2001 *BitStreams,* Whitney Museum of American Art, New York, New York · *Digital: Printmaking Now,* Brooklyn Museum of Art, Brooklyn, New York 2000 *PICT,* Banff Center for the Arts, Banff, Canada · *Glee: Painting Now,* Aldrich Museum of Contemporary Art, Ridgefield, Connecticut and Palm Beach Institute of Contemporary Art, Palm Beach, Florida 1999 *Conceptual Art as Neurobiological Praxis,* Thread Waxing Space, New York, New York 1998 *Kind of Abstraction,* Seattle Art Museum, Seattle, Washington · *Contemporary British Art,* Denver Museum of Art, Denver, Colorado

36 **Maz Maz,** 2002 acrylic on canvas, 86 x 57 in.
 Courtesy of Ronald Feldman Fine Arts, New York, New York. Photo: Hermann Feldhaus
37 **Dirac,** 2002 acrylic on canvas, 70 x 153 in.
 Courtesy of Ronald Feldman Fine Arts, New York, New York. Photo: Dennis Cowley

DAN HAYS

Born 1966, Kingston-Upon-Thames, England. Lives and works in London, England

EDUCATION Goldsmiths College, London, England, BA Honours, 1990
SELECTED SOLO EXHIBITIONS 2002 *Colorado,* Entwistle, London, England 2001 *Dan Hays,* Verein Jünger Kunst, Wolfsburg, Germany 2000 Entwistle, London, England 1999 Galerie Zürcher, Paris, France 1998 30 Underwood Street, London, England 1996 Laure Genillard, London, England
SELECTED GROUP EXHIBITIONS 2002 *Unscene,* Gasworks, London, England · *Land.escape,* VTO, London, England · *View Finder,* Arnolfini Gallery, Bristol, England 2001 *Happy The World So Made,* The Nunnery, London, England · *Ex Machina,* Ober die Zersetzung der Fotografie, Neue Gesellschaft für Bildende Kunst, Berlin, Germany · *Patterns: Between Object and Arabesque,* Kunsthallen Brandts Klædefabrik, Odense, Denmark · *Quotidien Aide (Les Locataires),* Ecole Superieure des Beaux-Arts de Tours, Tours, France 2000 *Serial Killers,* Platform, London, England 1999 *Painting Lab,* Entwistle, London, England 1998 *Soft Bundle,* Mostra D'Arte Contemporanea, Sant' Angelo, Italy · *Dimension Leap,* Trafo Gallery, Budapest, Hungary

40 **Colorado Impression X A (After Dan Hays, Colorado),** 2002 oil on canvas, 59-7/8 x 78-3/4 in.
 Courtesy of the artist and Entwistle, London, England
41 **Colorado Impression X B (After Dan Hays, Colorado),** 2002 oil on canvas, 59-7/8 x 78-3/4 in.
 Courtesy of the artist and Entwistle, London, England

YEARDLEY LEONARD

Born 1968, Washington, D.C. Lives and works in New York, New York

EDUCATION Barnard College, Columbia University, New York, New York, BFA, 1991
SELECTED SOLO EXHIBITIONS 2002 Dee/Glasoe, New York, New York 2000 *Yeardley Leonard: Recent Paintings,* Dee/Glasoe, New York, New York
SELECTED GROUP EXHIBITIONS 2002 *Christian Garnett, Shannon Kennedy and Yeardley Leonard,* Galerie Schuster, Frankfurt, Germany 2001 *Torben Giehler, Rachel Howard, and Yeardley Leonard,* Goldman Tevis, Los Angeles, California 2000 *Another Story All Together: Abstraction in Painting Today,* Castle Gallery, College of New Rochelle, New Rochelle, New York · *Useful Indiscretions: Works on Paper,* Geoffrey Young Gallery, Gt. Barrington, Massachusetts 1999 *Show,* Elizabeth Dee Gallery, New York, New York · *Andoni Euba, Yeardley Leonard, Angelina Nasso,* Jay Grimm, New York, New York 1998 *New Models: Envisioning the Real in Abstraction,* Robert McClain & Company, Houston, Texas

44 **Primal,** 2002 acrylic on canvas, 16-1/2 x 33 in.
 Collection of Michael Stewart, New York, New York. Courtesy of Elizabeth Dee Gallery, New York, New York
45 **Cleavage,** 2002 acrylic on canvas, 16-1/2 x 33 in.
 Collection of Ninah and Michael Lynne. Courtesy of Elizabeth Dee Gallery, New York, New York
 Anthem, 2002 acrylic on canvas, 16-1/2 x 33 in.
 Private Collection, New York, New York. Courtesy of Elizabeth Dee Gallery, New York, New York

RANDY WRAY

Born 1965, Reidsville, North Carolina. Lives and works in Brooklyn, New York

EDUCATION Skowhegan School of Painting and Sculpture, Skowhegan, Maine, 1990 · Alliance of Independent Colleges of Art Studio Program, New York, New York, 1986–1987 · Maryland Institute, College of Art, Baltimore, Maryland, BFA, 1987 · North Carolina School of the Arts, Winston-Salem, North Carolina, 1983
SELECTED SOLO EXHIBITIONS 2003 Weatherspoon Art Museum, University of North Carolina, Greensboro, North Carolina 2002 Derek Eller Gallery, New York, New York · Feature Gallery, New York, New York · Lump Gallery, Raleigh, North Carolina 2000 Derek Eller Gallery, New York, New York 1998 Jack Tilton Gallery (project room), New York, New York 1996 Kagan Martos Gallery, New York, New York 1995 Galeria Camargo Vilaca, Sao Paulo, Brazil 1994 Christopher Grimes Gallery, Santa Monica, California
SELECTED GROUP EXHIBITIONS 2002 *New York Art,* Ferdinand Schmelz Gallery, Linz, Austria · *Landscape,* Derek Eller Gallery, New York, New York 2000 *Painting Generation,* Kagan Martos Gallery, New York, New York · *Snapshot,* Contemporary Museum, Baltimore, Maryland and Aldrich Museum, Ridgefield, Connecticut 1998 *Message to Pretty,* Thread Waxing Space, New York, New York · *PULSE: Painting Now,* Rare Gallery, New York, New York 1997 *Prosthetic Garden,* Silverstein Gallery, New York, New York 1995 *Way Cool,* Exit Art, New York, New York 1994 *Desire,* Charles Cowles Gallery, New York, New York

48 **Episode,** 2002 acrylic, carborundum grits, micro-glitter on canvas, 30 x 24 in.
 Courtesy of Derek Eller Gallery, New York, New York
49 **Acrobat,** 2002 acrylic, oil, micro-glitter on canvas, 30 x 24 in.
 Courtesy of Derek Eller Gallery, New York, New York
 Immigrant, 2002 acrylic, oil, micro-glitter on canvas, 30 x 24 in.
 Courtesy of Derek Eller Gallery, New York, New York

AMY YOES

Born 1959, Heidelberg, Germany. Lives and works in New York, New York

EDUCATION School of the Art Institute of Chicago, Illinois, BFA, 1984
SELECTED SOLO EXHIBITIONS 2001 *Ubiquitous Kiss: New Painting,* Stefan Stux Gallery, New York, New York 2000 Stefan Stux Gallery Project Room, New York, New York · *In the Cursive Style: Love,* Roger Ramsay Gallery, Chicago, Illinois 1995 *Paintings,* Space Gallery, Chicago, Illinois · McKinley Park Public Library, Chicago, Illinois 1993 *The Shadow of the Clouds on the Sea (with Fernanda Fragateiro),* Museu de Arte Contemporânea, Madeira, Portugal · Galeria Porta 33, Madeira, Portugal 1992 *Vivace Cantabile,* Chicago Cultural Center, Chicago, Illinois
SELECTED GROUP EXHIBITIONS 2002 *Artists to Artists,* Ace Gallery, New York 2001 *The Fusion Show,* 450 Broadway Gallery, New York, New York · *Dis-Ornamentation,* Second Street Gallery, Charlottesville, Virginia 2000 *Flat File,* Bellwether, Brooklyn, New York 1999 *Tabula Non Rasa,* Herron Gallery, Indiana University/Purdue University, Indianapolis, Indiana and I-Space, Chicago, Illinois 1998 *Urban Art,* Expo `98, Lisbon, Portugal 1996 *Plain Speak: Abstract Artists from Illinois,* Chicago Cultural Center, Chicago, Illinois · *Reveries,* Ford Center for the Arts, Knox College, Galesburg, Illinois 1995 *Public/Private,* NIU Gallery, Chicago, Illinois

52 **Dividing Thens by Nows,** 2000 oil on canvas, 60 x 84 in.
 Courtesy of Roger Ramsay Gallery, Chicago, Illinois and Stefan Stux Gallery, New York, New York
53 **Continental Murmur,** 2002 oil and acrylic on linen, 60 x 48 in.
 Courtesy of Stefan Stux Gallery, New York, New York
 The Second Pink, 2002 oil and acrylic on canvas, 60 x 48 in.
 Courtesy of Stefan Stux Gallery, New York, New York

PETER ZIMMERMANN

Born 1956, Freiburg, Germany. Lives and works in Cologne, Germany

EDUCATION Akademie der bildenden Künste, Stuttgart, Germany, 1984
SELECTED SOLO EXHIBITIONS 2002 Klemens Gasser & Tanja Grunert, Inc., New York, New York · Galerie Emmanuel Perrotin, Paris, France 2001 Galerie 20–21, Essen, Germany · *Flow,* Kunstverein Heilbronn, Germany · Kunsthalle Erfurt, Germany (with Herbert Wentscher) · Galerie Meile, Luzern, Switzerland 2000 Six Friedrich & Lisa Ungar, Munich, Germany (with Thomas Locher) 1999 Galerie Meile, Lucerne, Switzerland 1998 *Eigentlich könnte alles auch anders sein,* Kölnischer Kunstverein, Cologne, Germany
SELECTED GROUP EXHIBITIONS 2001 *Show,* Kunsthalle Erfurt, Germany · *art&economy,* Siemens Kulturprogramm, Deichtorhallen, Hamburg, Germany 2000 *Reality Bites,* Kunsthalle Nürnberg, Nuremberg, Germany · *Close up,* Kunstverein im Marienbad, Freiburg, Germany and Kunstverein Baselland, Basel, Switzerland · *Metro>polis,* Fondation Bruxelles, Brussels, Belgium 1999 *Billboard Project,* The Liverpool Biennial of Contemporary Art, Liverpool, England 1998 *Stadt Kunst,* Kunstverein Bonn, Bonn, Germany 1997 *Glossy,* Galerie Michael Janssen, Cologne, Germany 1996 *Surfing systems–die Kunst der 90er,* Kunstverein Kassel, Germany 1995 *shift,* Stichting de Appel, Amsterdam, The Netherlands 1993 *Aperto,* Venice Biennale, Venice, Italy

56 **Strip B,** 2002 epoxy on canvas, 49-1/4 x 98-1/2 in.
 Collection of Kimberly Light, New York, New York. Courtesy of Klemens Gasser & Tanja Grunert, Inc., New York, New York
57 **Plastik,** 2002 epoxy resin with pigments on canvas, 106-1/4 x 67 in.
 Collection of Burt Aaron, Franklin, Michigan. Courtesy of Klemens Gasser & Tanja Grunert, Inc., New York, New York
 Islands I, 2000 epoxy resin with pigments on canvas, 106-1/4 x 66-7/8 in.
 Courtesy of Klemens Gasser & Tanja Grunert, Inc., New York, New York

Cranbrook Art Museum is a non-profit contemporary art museum and is an integral part of Cranbrook Academy of Art, a community of artists-in-residence and graduate students in art, architecture and design. Cranbrook Academy of Art and Art Museum are a part of Cranbrook Educational Community, which also includes Cranbrook's Institute of Science, Schools and other affiliated cultural and educational programs.

Cranbrook Art Museum is supported in part by *ArtMembers@Cranbrook*, The Michigan Council for Arts and Cultural Affairs, and the fund-raising activities of the Serious Moonlight Steering Committee, the Museum Committee, and the Women's Committee of Cranbrook Academy of Art and Art Museum.